EXPRESSIVE DRAWING
Mastering the Art of Sketching

ISBN 0-917121-02-3

EXPRESSIVE DRAWING
Mastering the Art of Sketching

by Bob Bates

Credits

Publisher
Dennis Kapp

Executive Director
Edward J. Flax

Art Director
Phillip C. Myer

Editor
Vera A. Donovan

Editorial Assistant
Dorothy Schwartz

Assistant Art Director
Jean Brubaker

Production Artist
Carole A. Stone

Photographer
Michael LaRiche – Product

Photographer
Bob Bates – Illustrations

Typesetter
Lynn Dinnell

Printed in U.S.A.

First Printing, 1985

CONTENTS

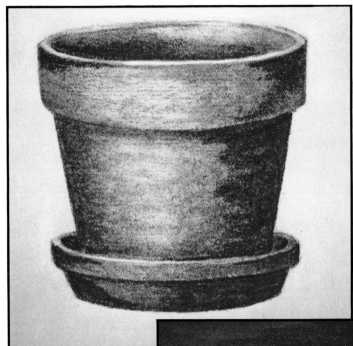

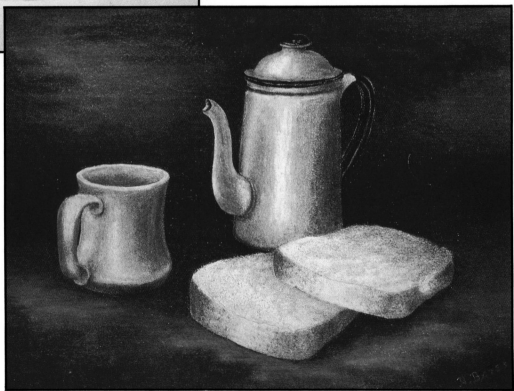

DEDICATION

"I would like to dedicate this book to my wife, Bernita."

MEET THE AUTHOR

Bob was born in Illinois where his initial art training began. After an education in Art and Photography, his first show was held in New Haven, Connecticut in 1950. The show included sketches and pastel paintings of still life and landscapes.

For the past twenty-five years, Bob has had a career as a product designer. He has received numerous awards, his achievements are well known, and his designs widely accepted.

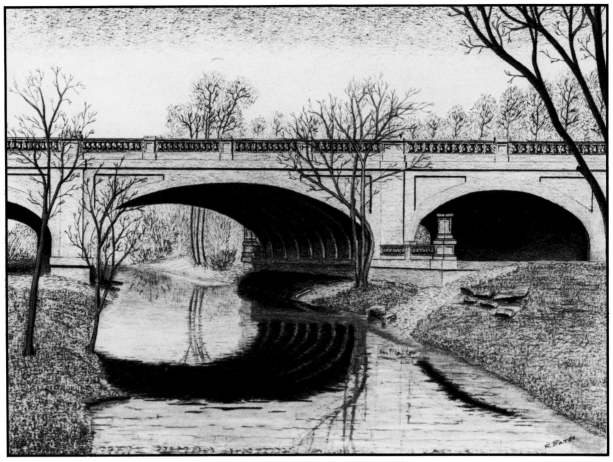

BRIDGE AT NEW HAVEN

Most of us have at some point in our lives looked to a creative medium through which we could better express our thoughts and feelings. Self-expression is a need most of us share, yet traditionally most of us have been taught effective speaking and writing skills for this purpose. Few of us have had formal art training providing us with the ability to channel our creativity through other media - drawing, painting, and sculpting.

If you have had little or no art training and are interested in finding an art medium through which you could express yourself, then this book is for you. Whether your end goal is drawing, painting, or another art form, the skills developed through the sketching exercises in this book will help you to gain a sense of appreciation for fine art forms and many other fundamental concepts necessary to develop good artistic skills. With these skills, you will be able to express yourself with a tremendous sense of accomplishment and gratification.

The creation of satisfying art comes from a thorough working knowledge of materials, art form, proportion, perspective, and composition. Application of this knowledge will lead to the development of good sketching skills and technique.

It is important to study the rules and principles presented in this text before attempting to sketch on your own. Everything has its price - here the price is the desire to learn and the willingness to practice. Practice is of paramount importance in developing good drawing skills and creating satisfactory art. Producing unsatisfactory art can lead to discouragement which can be avoided if you take the time to do the exercises included in this book.

Understanding the art theory is of equal importance because it will help you to further understand the purpose of developing good drawing skills and art form.

Once your skills begin to develop, you will see potential subjects for your art all around you. When you do not see subject matter, you will search for them. Your reward will come when you will be able to successfully represent chosen subjects artistically.

The text has been presented in a progressive sequence. It is important that you clearly understand *one concept before moving to another.* Again, emphasis is placed on continued practice. This will result in hours of fun and a collection of your very own art—your self-expression.

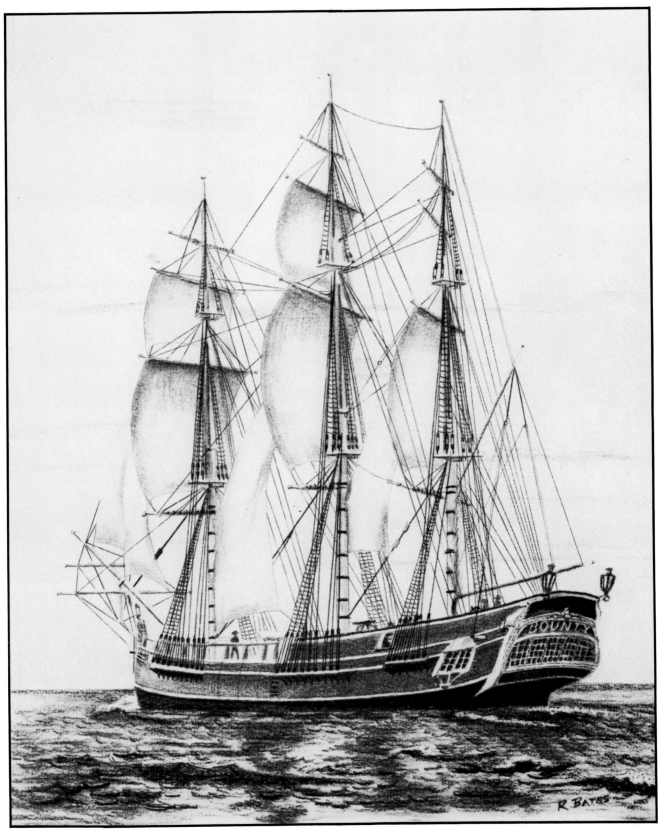

H.M.S. BOUNTY

COMPOSITION

The lesson plan that follows in this book will give you an opportunity to become familiar with various media and develop fundamental sketching skills. Before you do this, it is important that you understand the basic elements of composition.

Composition is the relationship of all parts with respect to the whole. When a student can appreciate the elements of composition, the ability to record impressions will follow.

The artist must look at his subject matter in terms of lines and masses. There is no benefit to learning that an "S" line is desirable if the artist does not appreciate such a line in nature. The line of surf along a sandy beach may be a good or bad line; it is the taste and judgement of the artist that will help him to decide. One can develop his own taste by studying the art of others. Through observation it can be seen how certain shapes and directions of lines are preferable to others in terms of aesthetics and composition.

You must select your own subject matter and medium, and use your imagination to apply the fundamentals of composition to your art. Imagination leading to individual interpretation is the key to becoming a sketch artist. Use the illustrations found in this book as a *guide* to creating your own sketches. Below are illustrations which feature basic elements of composition.

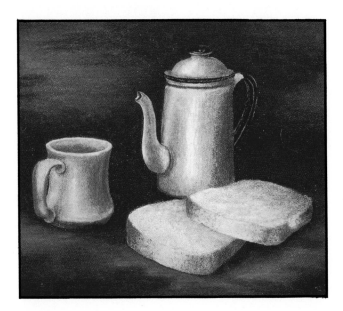

Illustration 1

A well composed sketch will provide the eye with natural movement from one area to another. Relative positions of the objects in a sketch affect the overall composition. Depth is obtained in this sketch by placing the bread in front of the teapot and by creating lighter color tones in the foreground and darker color tones in the background. In this example, materials used include

beige sketch paper, sanguine crayon, and charcoal pencil.

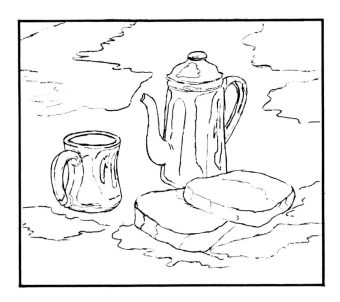

Illustration 2

In a still life sketch, keep objects in proper porportion. Use a ruler to help establish a ratio between the objects.

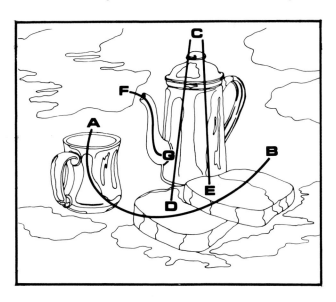

Illustration 3

There are three forms that make up this setting. The predominant eye movement continues along the line formed by "A" and "B". This composition is based on a curved line leading from the cup through the center of both pieces of bread. The contrast created by these three objects and the background controls the scene. The cone formed by the teapot, "D-C-E" is in the form of an acute angle and imposes little energy to the scene. Finally, to provide rhythm and compliment to "A-B", the spout provides an "S" curve in the line formed by "F" and "G". The overall line formations reveals a harmonious movement that is quiet and restful.

COMPOSITION

In sketching complex subject matter for example, the landscape, you should consider relative scale as opposed to exaggerated scale. When the eye scans a scene, the impressions visioned are quite unlike anything that could be included in a sketch. If you try to put everything into the sketch, the result is often remoteness, distorted space and form relationships, and confusion of scale. You can avoid this by placing an object in the foreground that will give the observer a sense of space and scale relative to the background. Selection of a predominant foreground subject must help to relate the feeling of the entire sketch.

Imagination is a very essential attribute to the artist, a mental image is conceived and put into a form that can be recognized by others. This is also true in music, writing, and poetry. Imagination is a gift that can be enhanced by the study of composition and development of skills and can lead to the creation of numerous artistic works.

Composition has been divided into nine areas for the purpose of study. These include spacing, massing, lines, balance, detail suppression, accent, depth, figures in landscape, and genre. These will be described in the following sections.

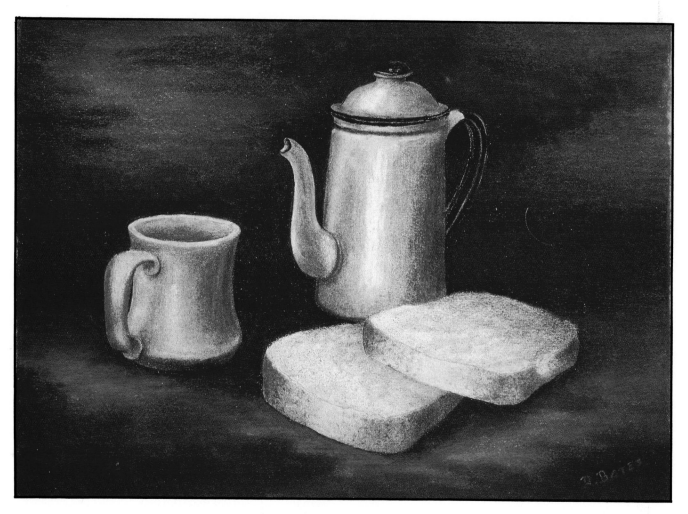

TEA AND BREAD

A simple concept in sketching is an arrangement of lines cutting into a rectangular space creating an interesting image. The rectangle may be bound by lines, the edge of the paper, or may be representative of an object in a scene.

Illustration 4

Potential mass areas are suggested with space divisions and lines.

When a blank space has been cut into areas of varying shapes and sizes, interest is aroused when the basic elements of design are viewed. This space can be simple or complex depending upon the number and direction of the lines.

Illustration 5

Interest can be aroused by simple line placement.

There are many ways to divide a space with lines and masses. The results depend on the disposition of the lines and the arrangement of the masses or tonal areas. The finest effects often present themselves as surprises.

A symmetrical arrangement is usually less interesting than one that varies in shapes and sizes. A rectangular space which has been bisected *horizontally* is less interesting than one divided horizontally either below or above the center. An interesting addition would be a vertical line.

Illustration 6

A symmetrical division is less interesting than a division above or below the center.

Illustration 7

An off center, vertical division will also add interest.

This cutting of space into various shapes or areas, sometimes varying tonal qualities, is referred to as SPACING. The areas of tone are called MASSES. The success of a sketch depends greatly on the effectiveness of the spacing and massing.

MASSING

The masses together with the spaces govern the design of the sketch. When you look at a sketch with a half-closed eye, you are attracted to the masses. The pattern is more easily interpreted when fine detail has been eliminated. If the masses are pleasing, the composition is usually satisfactory.

To further appreciate and understand the impact of masses on the observer, you should make frequent visits to museums and galleries to view paintings and sketches. The art with strong and interesting masses will stand out from the rest.

Good masses are not necessarily dependent upon their sizes. Good mass structure can be accomplished by forming a simple design.

This aspect of sketching helps you to understand why an artist is selective about his subject matter; he is not always content taking a fragment of nature and attempting to transfer it to paper. He must consider shapes, lines, and spacial relationships that suit his *taste*. He will then be effective in his artistic approach. This is why you must learn to see subjects in terms of lines, shapes, and masses. You will be able to determine from what point to sketch your subject so that the lines and masses form agreeable space divisions.

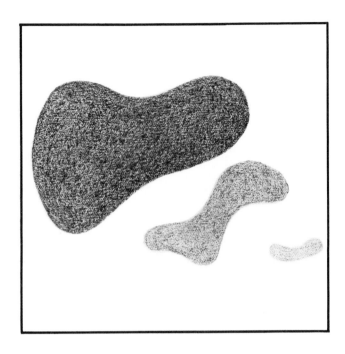

Illustration 9
Masses do not have to conform to any prescribed forms or intensities. In viewing a group of mass areas, the observer is free to let his imagination identify the subject matter in his own way, especially when there is no supporting identification.

Sometimes it will be necessary to accentuate masses so they will predominate. This can be achieved by spacing.

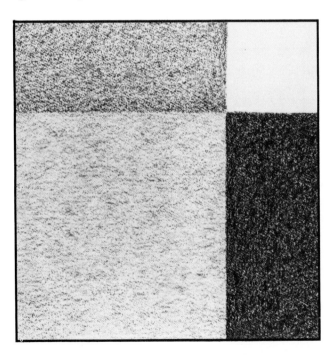

Illustration 8
Suggested masses are realized through shading. The divisions in Illustrations 6 and 7 suggest mass structure, which in this sketch gain strength with shading.

Consider three masses within a sketch. When these masses are placed in an interesting order, the essence of the masses is not that important.

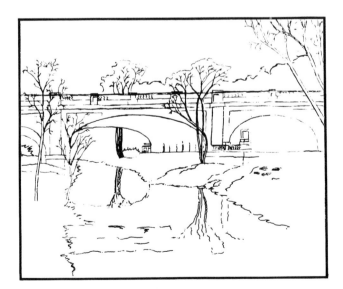

Illustration 10
In the preliminary layout of a sketch, the artist has already determined how the finished sketch will look — how and where the mass areas will be placed. Remember to apply the rules of perspective. Make several sketches of the scene before you decide which view will best represent the sketch.

MASSING

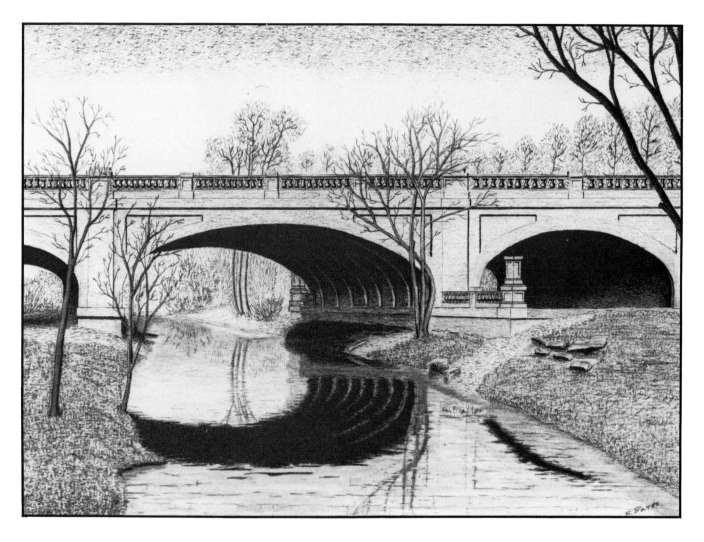

Illustration 11
BRIDGE AT NEW HAVEN
 The success of the sketch depends on the disposition of the lines and arrangement of the masses. A symmetrical arrangement of masses is generally less interesting than a random arrangement with balance. If the masses are pleasing and interesting at a first glance, then the sketch can be considered a success.

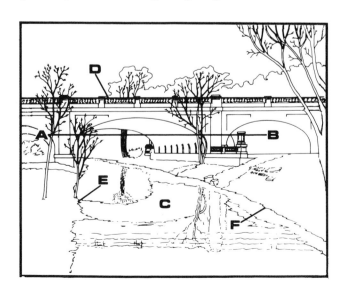

Illustration 12
 Primary mass areas will be found along the "A-B" line and the reflected area at "C". These areas comprise the most significant part of the sketch; everything else simply helps to coordinate and balance the sketch. Element "D" helps to tie-in these masses. An interesting curved line is found at "F" and will gently lead the eye of the observer to the intersection of "A-B". Without this curve, the sketch would be significantly less effective. The edge of the water on the opposite side of the creek, "E", provides an irregular juncture between water and land and a means for the creek to diminish towards the horizon offering depth to the sketch.

LINES

Lines have a significant role in attracting interest to a drawing. They not only determine the harmony, by relating the spaces and masses, but by their direction give impressions of repose or agitation, gaiety or gloom, peace or turmoil. The subject of the sketch will not express its true sentiment without the support of the *line language.*

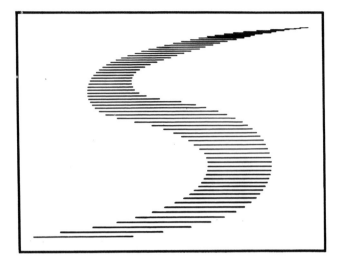

Illustration 13
Lines can do more than fix the relationship of the masses. They can provide expression and harmony if we choose to use them this way.

Illustration 14
Diagonal lines suggest action and energy. The diagonal lines of a person running, viewed from the side, would be leading the eye in the direction he is going.

Horizontal lines are used to suggest repose and restfulness — for example, the lines of the horizon against a lake or the low clouds of a sunset. Long lines can separate the parts of a sketch and must be used sparingly; they act as barriers to vision. Such lines, if necessary, can be broken with vertical or diagonal lines.

Diagonal lines suggest action and energy. They are lines of motion and lead the eye in the direction they take from the baseline of the sketch. Diagonal lines can be balanced and their energy reduced by including lines inclined in the opposite direction.

A diagonal or curved line is more pleasing than a continuous, straight line, horizontal or vertical, simply because the eye can follow a diagonal or curved line with less fatigue.

Illustration 15
A curved line is more pleasing than an uninterrupted straight line.

The concentrated effort that is needed to follow a horizontal or vertical line is tiring because only a few of the eye muscles are used. Variety is restful because it exercises the entire muscular system of the eye.

A sketch containing a number of curving horizontal or vertical lines, all slightly different in length — such as a sketch of a sailing ship with shrouds, masts, and sails — would be restful to the eye because, again, the eye would gracefully follow the composition of the subject matter.

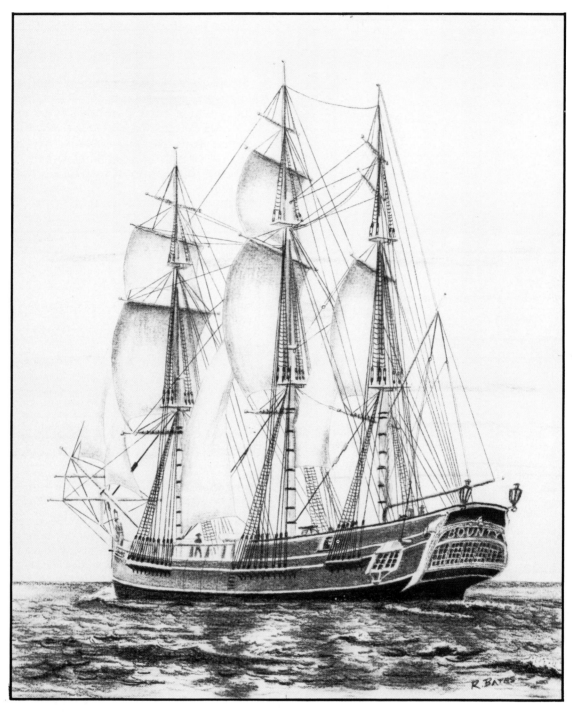

Illustration 16
H.M.S. BOUNTY

By varying the lines in a sketch, there is less muscular effort and, therefore, less fatigue. This sketch is restful and pleasing. The eye does not concentrate on any single line but shifts from line to line, noting slight variations in the vertical lines.

One of the most pleasing arrangements of straight lines can be seen in a triangle. Almost any triangular formation of lines, with the possible exception of the right triangle, would be a good selection for a sketch because it offers variety. A right triangle can be distracting because there are perpendicular lines; the effort to turn abruptly from the vertical to the horizontal is disruptive. Triangles, other than right triangles, suggest stability and firmness, and are good space fillers. Their outlines suggest other triangular shapes in conjunction with the edges of the sketch.

LINES

When two lines form an acute angle, it is easy to follow them simultaneously. The gradual approach of the lines to a common point eases the reversal of the direction.

Reversing direction, graphically or by suggestion, conveys an impression of action. The spires of a cathedral or tall, pointed, pine trees form acute angles which are interesting and artistically satisfying.

When an obtuse angle is formed, the change from one direction to another is slow and easy which gives the impression of rest rather than activity. The valleys between hills often form obtuse angles and appear peaceful when represented in a sketch.

Illustration 17
A triangle is one of the most pleasing arrangements of lines.

Illustration 18
Almost any triangular formation, with the exception of a right triangle, is appealing.

Illustration 19
It is easy to follow two lines that form an acute angle.

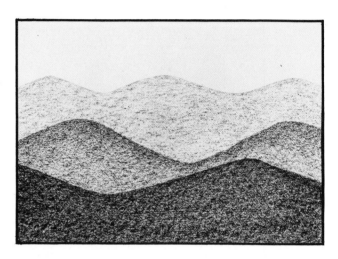

Illustration 20
An obtuse angle projects rest rather than activity.

Angles in visual scenic impressions are definite, yet the average observer does not take the time to explore why. These impressions are important enough to make use of them in selecting the subject matter of a sketch and developing composition.

You can also make impressions counter-act one another; too many lines in one direction can be balanced by drawing lines in another direction. This is why triangles are satisfying: the lines balance one another.

A curved line is soothing and restful. When following the course of a curved line, eye muscles move alternately resulting in little or no fatigue. A curved line conveys more beauty than a straight line and is more pleasing than a tangent. See Illustration #21.

The most satisfying curved line is the "S" curve, which is known as Hogarth's *line of beauty*. This line is often found in nature — the sinuous windings of a water-way or the outline of a mountain range — and is exemplified frequently in the human figure. It is interesting to notice how frequently this line is found in sketches even when the artist did not consciously create it. The "S" curve offers the balance and grace in a sketch that would otherwise be lifeless.

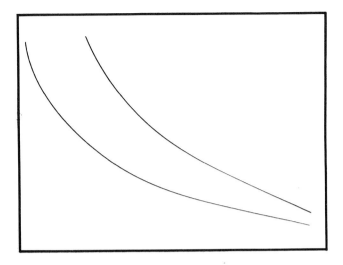

Illustration 21
A curved line is more relaxing than a straight line.

Illustration 22
The "Z" line composition is the embodiment of energy with its sharp, angular movement.

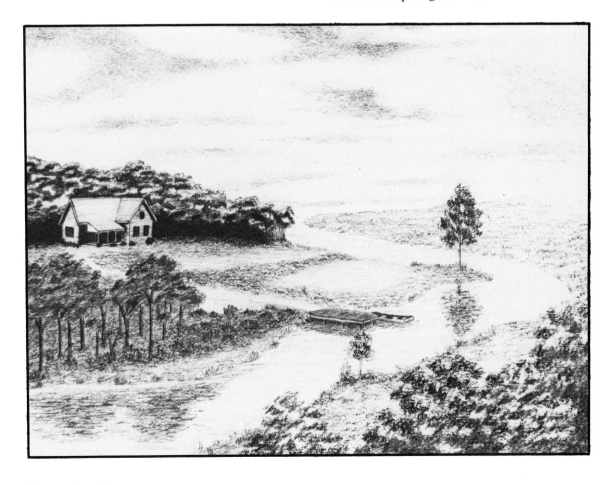

Illustration 23
The "S" shaped curve adds balance and grace to a sketch. This is a curve that is frequently found in a natural setting but often goes unnoticed.

The "S" curve can be found in a more angular form when it takes on the shape of a "Z". This, too, is a good line for composition offering more energy with its sharp, angular movement.

LINES

The single curved line can be a useful component in composition. Curved lines must be used sparingly: a sketch consisting entirely of curves would be weak and unstable. Such lines require an association with straight lines to establish strength in a sketch.

Thus far, structural lines, outlines of objects, and edges of tones have been discussed. There is another type of line which has a significant role in sketching. This is a line which is not clearly expressed but can be strongly felt — the *imaginary line.*

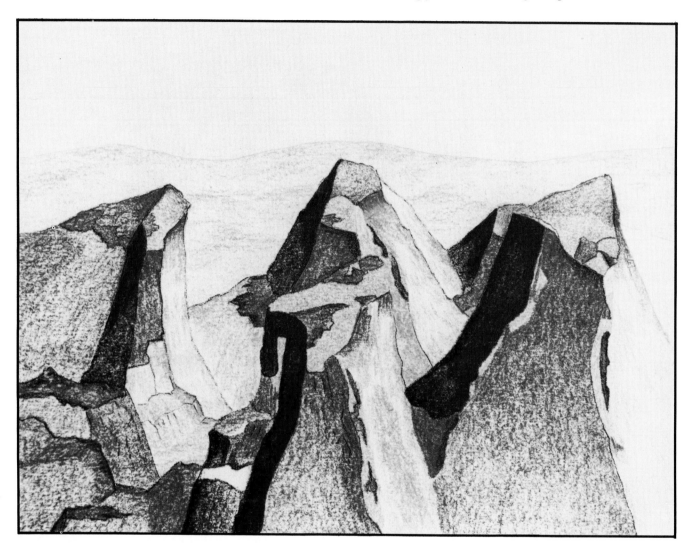

Illustration 24
Imaginary lines can be indirectly suggested and strongly felt.

The eye always connects objects following the shortest path between them. An example of this phenomenon can be observed in a portrait of a person dressed in dark clothing and posed against a dark background so that the face and hands are the only light elements in the picture. The eye connects these light areas with straight lines. In this instance, a triangular line arrangement is formed. The influence of this imaginary line can be considered by the artist when creating portraits and figure studies.

In sketching landscapes, suggested lines may be used frequently with positive effects; the tops of trees, small figures, or other objects in a landscape may be grouped so that a line connecting them will be pleasing and significant to the composition of the sketch. The eye will see at once that a circle encompasses the extended petals of a sunflower or that the outer points of a compound leaf could lay on an ellipse. The powerful influence of these imaginary lines will make the proper placement of accents so vital in sketching and painting. The roofs of distant buildings, the heads in a group of people, innumerable apparently unimportant objects, must all be considered with regard to their influence on line formations, real or imaginary.

Generally the subject of interest in a sketch should be located off center so that a sense of balance can be created. If the main subject is located in the center, the eye will rest upon it and fatigue. The exception would be in a portrait when concentration on the central object is the primary objective of the art.

Balance can be observed as two forces acting upon a fulcrum. This is a convincing mechanical principle. To create this balance you should introduce secondary objects so the observer can obtain relief by panning from the primary to the secondary objects. When planning a sketch, you should imagine the fulcrum nearer the heavier masses and the lighter masses farther away. This application provides the sketch with a satisfactory visual balance.

A centrally located object cannot be balanced by any other objects in a sketch — it must stand alone. There are few subjects significant enough to occupy the center of a sketch.

The subject of interest in a sketch can be emphasized by the direction of lines or tonal quality. In a well composed sketch, the eye should be attracted to the subject but should also get relief by passing to other less significant points. When there will be two or more significant subjects in a sketch, competition will exist and the balance will be nonexistent. The eye will be forced to move from one subject to another, the harmony will be disrupted, and the eye will become fatigued.

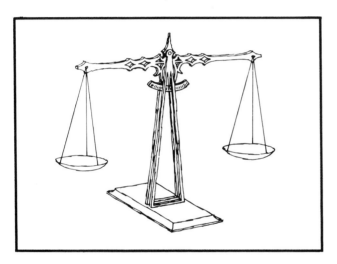

Illustration 25

Balance can be described as two forces acting upon a fulcrum — a perfectly convincing mechanical principle.

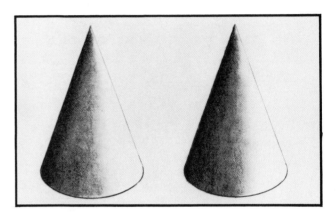

Illustration 27

If there is more than one object of equal importance in the sketch, the balance will be destroyed.

In an attempt to create balance, the artist sometimes places too many lines or too many objects of equal importance in a sketch. This causes confusion, discomfort, and eye strain. For instance, sunlight shining through foliage creates a number of irritating bright spots and is, therefore, not conducive to good composition. A landscape with two roads or paths of equal strength, branching off in different directions, does not constitute good composition.

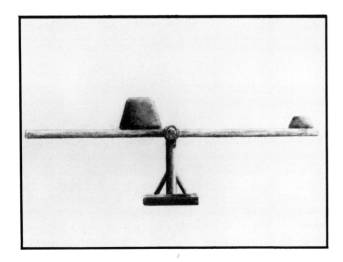

Illustration 26

A 50 pound weight, 1 foot from the center, would be perfectly balanced by a 5 pound weight 10 feet from the center of the other end of the balance arm.

Illustration 28

The bright spots in these trees cause visual irritation, this is not conducive to good composition.

DETAIL SUPPRESSION

In order to properly appreciate masses, it is sometimes necessary to eliminate some of the fine detail in a sketch. When elaborate detail is employed, the pattern is observed but the impressiveness is lost. When we look at a tree, we do not want to distinguish all the leaves or the labyrinth of boughs and twigs. We would rather have a composition displaying general character of structure and the foliage as an arrangement of masses.

There are numerous methods of detail suppression in sketching. These include varying the shading technique or softening the outline of any predominant details that would otherwise lend excessive detail to the finished sketch.

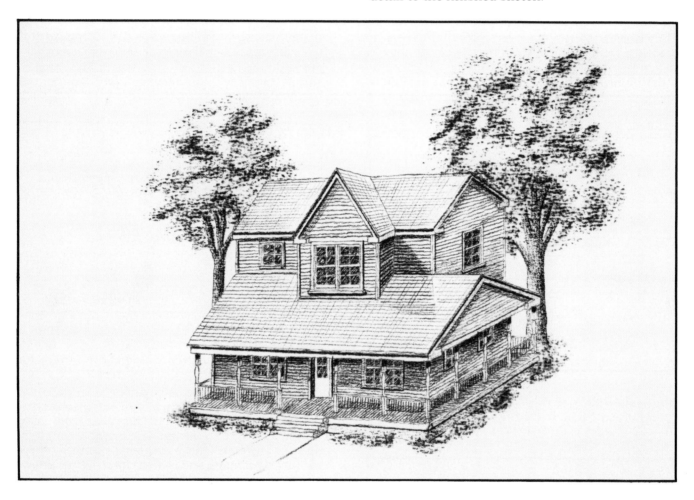

Illustration 29

In this illustration, the detail of the house is sufficient to make the house the subject. While the trees are adequately represented, they do not detract from the house.

You can include detail in the masses and yet still retain a *breathing space* area. This is provided the detail is properly subdued and does not attract unwarranted attention. With such technique we can suggest the vibrant quality of sunlight and render the shaded portions better than any other means.

The use of heavy textured paper aids in detail suppression. The texture of the paper picks up the mottled effects of the medium used directly in relationship to the degree of texture on the surface of the paper. You can control this effort with the use of the stump. Rub the medium with the stump until the desired texture is obtained. Detailed explanation of this technique can be found in Lesson section.

In sketching a portrait, the same technique is used to give substance to areas such as hair or lacy garment. Of course, the quality of definition in a sketch is not always an important factor in its success. A sketch is not necessarily pictorial because a shading technique has been used on the mass areas; on the other hand a sketch is lacking in pictorial effect if the details are sharply defined. Definition should neither be noticeably sharp or noticeably subdued. If the definition does not call attention to itself, it is safe to say that it is satisfactory.

As referred to earlier, keeping the tones in the sketch quiet and simple and avoiding a significant contrast of light and dark or a drastic range of tones is desirable. Though, if this technique is carried to the extreme, the result can be weakness and monotony. If a sketch is composed of only a few tones, an accent is usually necessary to pull them together and make the sketch interesting. If the prevailing tones are dark, the accent may well be light, while if light tones predominate the sketch, a dark accent may be needed. Very often the accent is used to emphasize the primary object of interest in the sketch. Occasionally the main object may present sufficient contrast to make it prominent.

When the accent forms the principal object of interest in the sketch, its position in the sketch must be carefully considered. As a rule, a point about one third of the width of the sketch, from either the top or bottom, and about one third of the way in from the side will be a strong position for an accent. These points may be observed by imagining that your sketch space is divided vertically and horizontally into thirds by lines intersecting at four points.

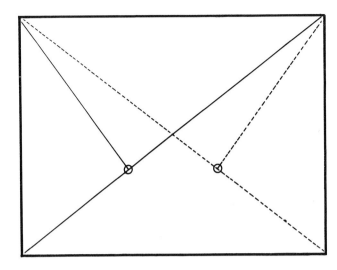

Illustration 31

A popular method of determining the strong positions for accents is shown above.

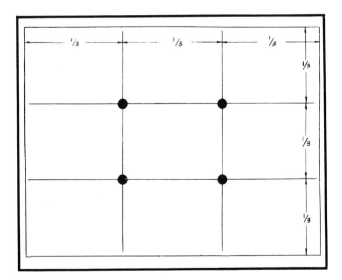

Illustration 30

A strong position for an accent would be at one of these four points.

The shape of the sketch does not matter: it may be a vertical or horizontal, rectangle or a square. In planning the composition of the sketch, it is a good idea to get prominent accents as near to one of these points as possible.

Another very popular method of determining the strong position for an accent in a sketch is to draw a diagonal and then erect a perpendicular line from the diagonal to an opposite corner as indicated in the diagram.

DEPTH

Most sketches require depth. Whether the subject is a still life or a landscape, some method will be necessary to suggest depth. In the case of landscapes, depth can be achieved by decreasing the width between receding horizontal lines; reducing the height of trees, hills and mountains; or distinguishing distant plains by a reduction of shading and detail on those levels farther away from the observer.

When planning a sketch try to visualize the effect of controlled plane distance. In still life scenes, this effect must be communicated with less emphasis. In settings of multiple objects, they can be overlapped. Proper perspective will be necessary to convey realism.

Some scenes will be enhanced by the use of perspective, however, it must be remembered that in many simple compositions, perspective alone will not impart realism without the use of gradual reduction in detail and shading.

A change in shading value will often be sufficient to impart the visual recognition of depth. To accomplish this, keep the heavier shading in the foreground and decrease the density of shading as planes are developed in the background. When creating a sketch, develop those planes that are farthest away first, then continue forward. For this reason, you must visualize the various planes and the density of the necessary shading while you are planning the sketch.

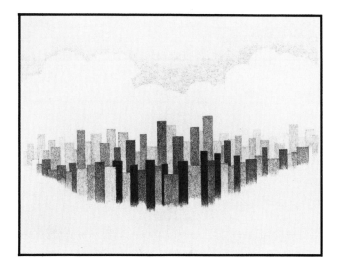

Illustration 32

As shown in this illustration, gradual reduction in shading will suggest depth. This illustration imparts the feeling of buildings in a large city. The buildings that are farther away are lighter.

Illustration 34

Nothing more than change in subject size and shading will convey the feeling of distance. This is one of the most important elements in a well developed sketch. This gives us a feeling of a third dimension and makes it easy for us to identify the overall scene and subject.

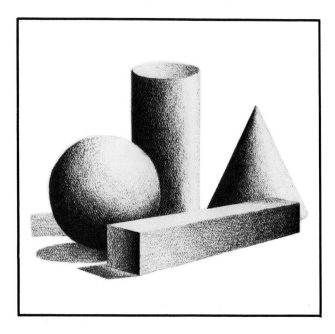

Illustration 33

In multiple object settings, often the objects are overlapped when sketched.

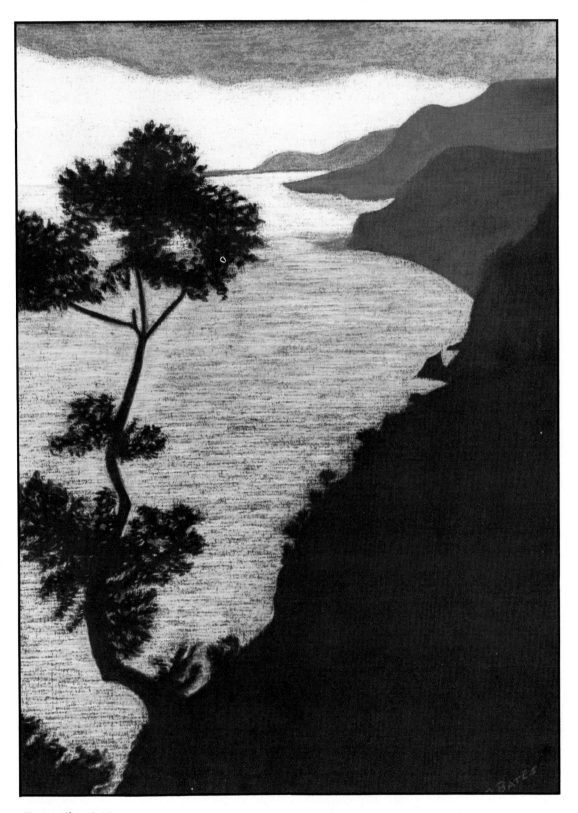

Illustration 34A
RIVIERA

 Depth perception can be achieved by overlapping objects in a sketch. Proper perspective is necessary to convey realism. Consideration is taken in the planning of the scene to visualize the effect of the controlled plane distance. Sketching in the negative form requires that the technique of suggesting detail be reversed.

DEPTH

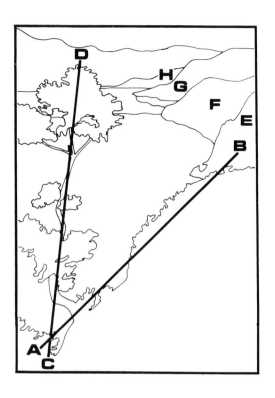

Illustration 34B

The same rules of composition apply to the negative form as do to positive sketching. This sketch shows a classic example of the implied acute angle, "A-B, C-D". Line "A-B" is slightly below center, reducing the mass of the ground. Had it been placed exactly through the center, there would have been too much mass in the lower right-hand corner. The angle is completed with the "C-D" which follows the trees and small mass clusters of leaves. The tree becomes the main subject of the sketch and lays off center to the left. To balance the strength of the tree, the masses "E, F, G and H" are provided. Mass areas of balance are placed farther away from the center of the sketch than the main subject, and thus the principle of mechanical balance is employed effectively. A sense of depth is provided through the use of color change using lighter tones of gray for each of the receding mass areas.

Detail of Illustration 32

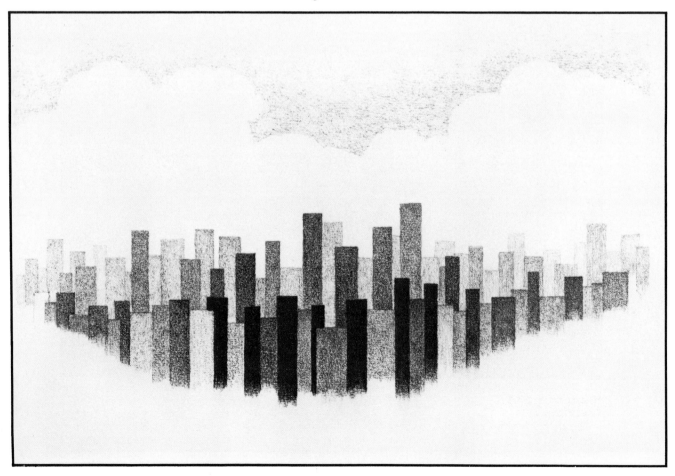

FIGURES IN LANDSCAPE

In a landscape sketch, a small figure or group of figures, carefully placed, may often serve as an accent. The figure in such a sketch is not merely an accent of contrasting tone, it is the main object of interest, giving the sketch a human element.

Whether the figures shall or shall not be included in a landscape depends entirely upon whether they are needed for the theme. If they help to tell the story, they should be included and their size and significance should be determined by the importance of the part they play in the overall composition. Size does not always determine the importance of figures in a landscape; they may be quite small and yet acquire considerable importance by their placement or their contrast in tone.

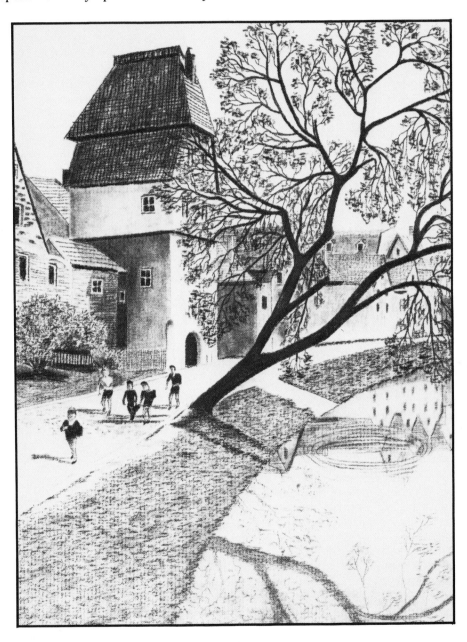

Illustration 35
DONAUWORTH

Figures in landscape must not be the main subject of a composition; they are subordinate in nature. Tonal planes are mass areas and become an element of good design and balance. Lines placed in the proper places add an interest to the scene that might not otherwise hold the observer's eye. Materials used in this sketch include Pompano Beach White sketch board, charcoal pencil, and carbon pencil.

FIGURES IN LANDSCAPE

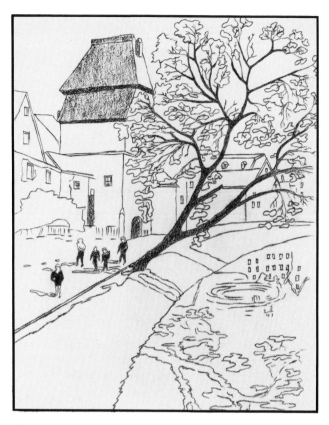

Illustration 36

In the preliminary layout of the sketch, determine where the mass areas will lay and how they will tie together with the details.

The arguments in favor of including figures in landscape sketches are as follows: they increase the range of emotions that can be expressed in the sketch; they help to accentuate the important features; they often provide the vertical or diagonal line that is needed to balance horizontals in the landscape; and a figure is sometimes helpful in suggesting scale and unusual height.

There are also arguments against the use of figures in landscapes. Figures are sometimes difficult to harmonize with regard to form and pose. Their expression, costume, and emotional qualities such as wildness, ruggedness, or desolation are lost in their presence without careful consideration. The artist must decide which is of greater importance, the landscape or the figures.

The laws of principality *and* unity and harmony *and* balance must always be observed. The sketch should tell only one story. If you decide that the figures are to form the main subject of interest in the sketch, you must try to make the landscape subordinate to the figures. In pastel painting, the skillful use of color can make idyllic landscapes in which a figure or group of figures is dominant in the painting. For the sketch artist using graphite or charcoal, this is more difficult. When there is only one figure intended to be the dominant subject, it

should be placed in agreement with the laws of composition. When there are two or more figures, one must dominate the others or they must be grouped together so that the interest will not be scattered. They may be engaged in some common occupation which will provide reason for the grouping.

If the sketch tells a story, figures may be needed. A safe rule is to omit figures when there is any doubt as to whether they are necessary. There may be figures, however, that are merely accessories; they may help to develop the landscape and not detract from it. On the other hand, if the figures tell the story, the landscape must be subordinate. Remember that any figures in a landscape are subject to the rules of perspective.

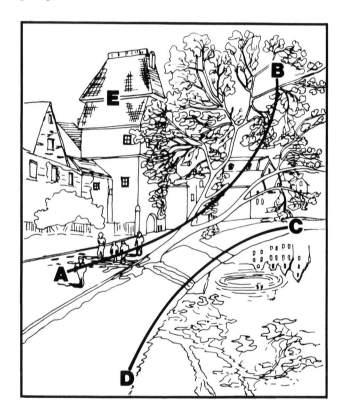

Illustration 37

Figures in the landscape are the subordinate theme in this sketch, although the placement of the figures is critical. A natural movement is noted in "A-B". The contrast of the figures and the tree trunk in relationship to the background makes these elements predominant objects in the sketch. Complimentary to the main theme is "C-D". This curve arches in the opposite direction of "A-B" indicating an hourglass configuration between the two. The observer's attention is drawn to the near center of the sketch in a compression of view and then is released and directed to the right of the center, at "B" and "C". With this activity taking place in the center of the sketch, there is a need for balance, this is provided by the roof sections at "E". Tonal value in contrast and physical size makes this mass an important balancing element and completes the compositional requirements.

Illustration 38
DEADLINE
 The genre scene is not from the portrait style approach when dealing with a group of people. Subjects should be involved in the everyday functions of their occupations or recreation. People should not look as though they are posing. When sketching, introduce various items of interest so that the eye may get relief by panning from item to item and back in various directions.

The subject of figures in landscape sketches leads to the consideration of genre work; when the figures are the subject of the sketch and the landscape is subordinate, the sketch falls into the class of genre rather than landscape.

Genre subjects often provide good material for the sketch artist. This type of subject matter can be handled well by sketching techniques. These sketches come in two forms: some are planned and arranged by the artist; and some occur naturally without any preliminary arrangement. Unity, balance, simplicity, and harmony must all be considered when sketching genre.

When depicting people involved in everyday activities, whether occupation or recreation, you are sketching in the area of genre. This is not portrait artwork, the subjects may even be facing away from the observer.

In developing genre sketches with subjects that are aware of being sketched, you should make a point to avoid representing the subjects as posing for the sketch.

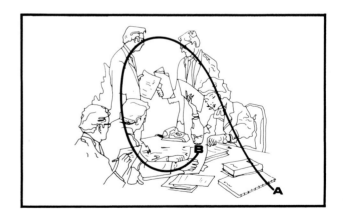

Illustration 39
 The subject of the sketch will not express its sediment adequately unless the language of lines is employed. The artist has to arrange the shapes and spaces to satisfy his taste and to arrange a pleasing pattern. Rhythm is the central theme of this composition and is found in the natural curve of line "A-B". Usually in the genre sketch, the bodies of the subjects will provide a main compositional line.

MATERIALS

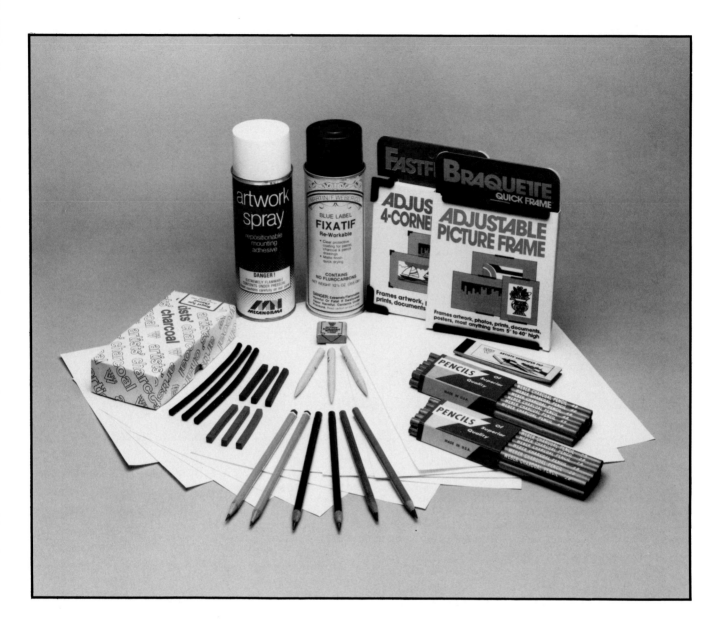

Pictured above and listed below are the materials required for the lessons taught on the following pages.

Graphite Pencils - one each HB and 2B
Charcoal Pencils - one each HB and 2B
Carbon Pencil - one 2B
Charcoal Sticks, Medium Diameter - 2 ea.
Compressed Charcoal Stick - 1 ea.
Sanguine Crayons - 2 ea.
Sepia Crayon - 1 ea.
Kneaded Erasers - 4 ea.
Stumps - 5 ea.
Tortillons - 3 ea.
Sanding Pads - 2 ea.
Fixative - 1 can
Sketching Paper - 12 sheets of varying textures
Aerosol Spray Mount - 1 can
Mounting Boards and Frames

Graphite Leads

Graphite leads originated three hundred years ago as an art medium and have since found use as writing instruments. Graphite pencils are made of graphite and clay. The ratio of these two elements determines the degree of hardness in the lead. Pencils generally come in grades of hardness from 6H to 6B: H is composed of hard group; B is composed of the softer group. Each group contains about six grades; grade HB would be in the middle.

6H	5H	4H	3H	2H	1H
		hard grades			
		HB			
		medium			
1B	2B	3B	4B	5B	6B
		soft grades			

The harder grades will draw light and sharp lines and retain their sharpness for a longer period of time. The softer grades are used for shading and creating bold, dark accents. Graphite leads are available in pencil form or in stick form in a variety of sizes. The sketch artist should obtain high quality pencils and leads. Some artists will use carpenter pencils that have elongated lead which can provide broad, flat strokes. The choice of pencil is entirely up to you, but you should try a variety of pencils in several degrees of hardness.

Graphite pencils are good sketching medium and provide the best results for initial line composition layouts. The final color of the sketched areas will have a silvery appearance which makes it difficult to get a deep, rich, black color in the shaded areas.

Illustration A
Graphite pencils have a silvery appearance. The hardness and color are dependent on the concentrations of the various compounds.

The shape of the leads is determined by the type of die selected. The extruded leads are air dried and oven baked. The time and temperature of the baking process also has an effect on the hardness of the leads.

Charcoal Pencils
Charcoal pencils will render soft, smooth drawings and are available in limited degrees of hardness, usually from 2B to H. Extremely fine sifting of the pigment and clay in the preparation of charcoal lead results in an extremely smooth finish on paper. Very intense black delineations can be obtained with this pencil.

Charcoal Crayon
Unlike lead encased in a wood graphite pencil, the charcoal pencil consists of ground charcoal which has been sifted, filtered, mixed with kaolin clay and then extruded into a shape that fits inside the pencil casing. This same material can also be extruded into a crayon. Unlike the crayons you used in elementary school made from wax, the charcoal crayon is made from this pure pigment as an additional art medium.

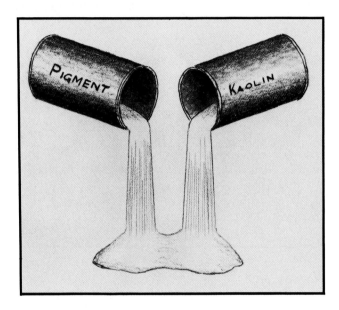

Illustration B
Most pencil leads are prepared from a mixture of water, pigment, and kaolin clay. The mixture is sifted, filtered, and mixed with a plasticizing compound to produce a paste.

Illustration C
After the paste is prepared, it is extruded through a die and baked.

MATERIALS

Kneaded Erasers

Like other erasers, kneaded erasers remove smudges, unwanted lines and can be manipulated to create accent spots on sketches. They are available in different sizes and varying degrees of softness. As suggested by its name, the eraser can be kneaded into any shape desired from a sharp point to a blunt stub. Harder erasers will provide pointed areas that will hold longer but are difficult to shape. The primary function of the kneader eraser is to lift the pigment from the paper rather than abrading it away, which would rub the pigment into the paper surface.

Illustration D

*Kneaded erasers may be shaped to conform to the size needed to **lift** the pigment from the sketch paper.*

The texture of the paper you use will have a direct effect on the quality of the finished sketch since the texture will be accentuated by the medium. Careful selection of paper color will also be necessary to obtain the desired effects. Shading can also be controlled by selection of the proper paper texture.

Any soft paper may be used for charcoal sketching and pastel painting. Papers of high pulp content will take the charcoal and pastel very well, but do not hold up if the sketches have to be re-worked to a great extent.

The color of the paper is important as the color base will be revealed in some spots, depending upon the techniques employed. For instance, it would not be wise to select a blue toned paper for a sunset or a brown toned paper for a seascape. Paper color should be complementary to the subject matter. A color opposite would provide a great deal of friction in the drawing.

When selecting texture, you must also consider the subject matter of the sketch. Rough paper would not be considered for a sketch involving a great deal of detail; the texture of the paper would interfere with the development of the detail.

The artist's style is also a factor in paper selection. If the artist prefers an unstumped, tonal sketch, and prefers to use a freehand stroke, then the texture of the paper will offer the final nature of the shaded areas. Emery paper or fine grade sandpaper can be used when a solid background is needed since the grit of the paper will quickly fill with color.

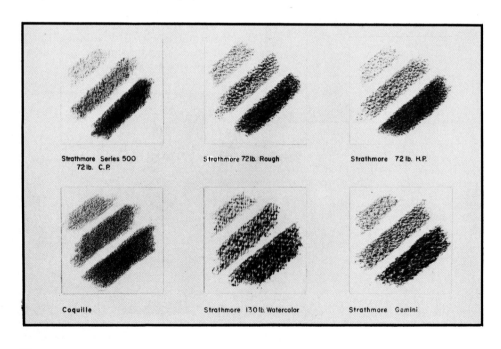

Paper
Illustration E

Get to know the textures of the various types of sketching papers. Consider the texture of the paper when planning to sketch a scene.

The attractiveness of the *hand made* textures developed in the manufacturing of sketching and pastel painting papers will afford a quality to the sketch that is impossible to obtain with any other type of paper used. These special papers must be selected according to the type of sketch and the desired result of shading texture. As you gain experience with different grades of pencils, crayons, and papers, you will learn how different media will affect different papers. In the beginning, select simple, small textured papers until you develop a feel for the media. Later try various textures that suit your taste and style.

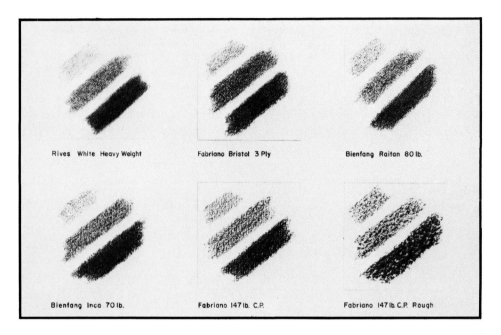

Illustration F

Sketches containing significant detail should be executed on lightly textured paper.

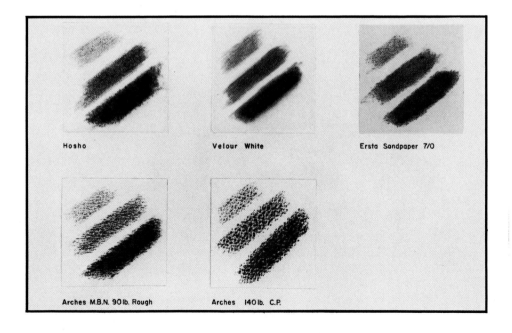

Illustration G

Try sandpaper when color saturation is desired. Use velour paper when only light tints of color are used. The result will be a very soft image.

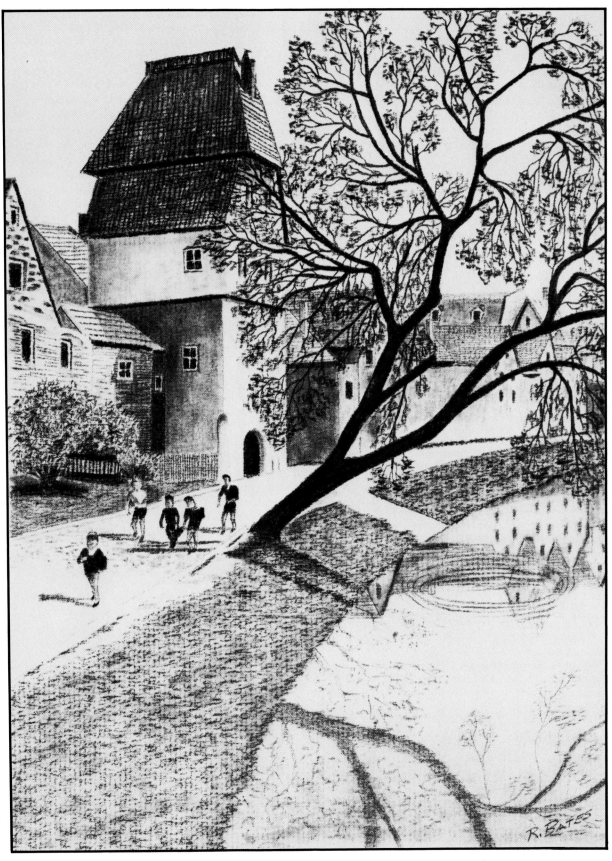

DONAUWORTH

LINES AND SHADING

LESSON 1

The ability to draw depends more on the development of skills than on natural ability. The supplies needed are minimal; you must basically learn all the rules and then practice. Draw only what interests you because drawing subject matter that does not interest you rarely results in a good sketch. Do not hurry. Continual observation and constructive self criticism will result in satisfying art work.

Using a pencil sharpener, knife, or sanding pad, sharpen an HB graphite pencil to prepare for your first lesson.

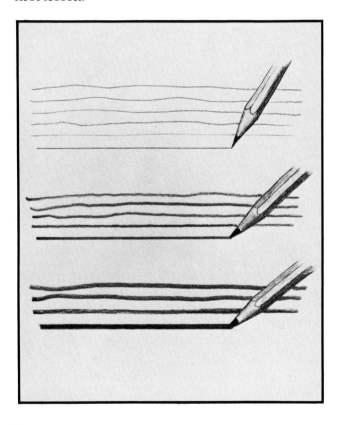

Illustration 40
For fine lines, the graphite pencil should be sharpened in a pencil sharpener. For broader lines, the pencil should be sharpened to a chisel point.

Think more about what you are drawing rather than how you are drawing. Take a sheet of sketch paper with a lighter texture and practice making lines of different thicknesses until you are able to control the straightness, width and density of the lines. Rather than carefully guiding the pencil, draw with spontaneity, then apply the control necessary to obtain the desired line.

You are now ready to try shading. Once again, think about what you are drawing rather than how you are drawing.

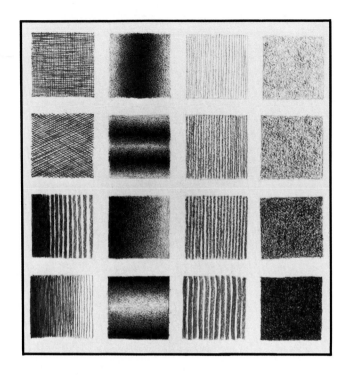

Illustration 41
An endless variety of shading techniques are possible. The style of shading should be developed to fit the texture desired and the artist's technique.

Practice shading on a fresh sheet of paper. Place the paper on a pad to provide a cushion which will greatly improve the quality of the shading. Sharpen a 2B pencil on the sanding pad. If you have selected a broad shading stroke first, the pencil may be sharpened to either a chisel point or a flat point so that more of the pencil is in contact with the paper.

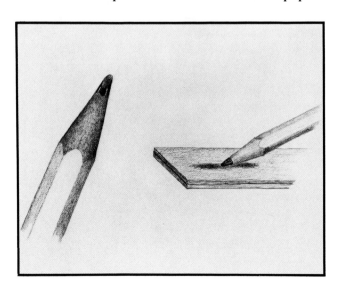

Illustration 42
A chisel point is obtained by rubbing the pencil at about a 20 degree angle to the sanding pad.

LINES AND SHADING

Continue practicing until you are able to reproduce the shading values shown in Illustration 41. There are basically two ways to do shading: the first is to apply sufficient pressure to the medium so that the desired effect is obtained with one stroke; the second is to go over the area to be shaded several times with a lighter stroke, *developing* the area. The latter method provides the artist with more control over the development of the shading.

To taper the shaded area, you apply pressure to the pencil at the beginning of the stroke, and then lift up during the stroke. This will *feather* the stroke, bringing out the full texture of the paper.

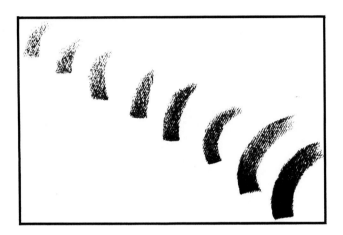

Illustration 43
*Apply pressure to the medium at the beginning of the stroke and then release the pressure slightly during the stroke. This will **feather** the stroke, bringing out the full texture of the paper.*

Train yourself to look for subjects that are interesting and try to visualize what the finished sketch will look like before you begin. Imagine where the subject will look best on the paper.

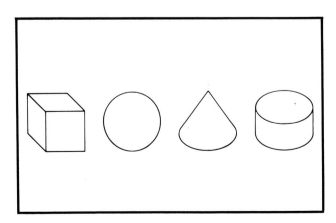

Illustration 44
Basic forms offer good sketching experience for the beginner.

Now try to sketch one of the basic shapes. Sharpen the HB pencil to a very sharp point using a pencil sharpener, knife, or sanding pad. Pick one of the shapes and think about sketching it five inches high. Be sure to try to center the sketch. Sketch using a series of fine lines, linking each stroke to the end of the previous stroke. Keep adding light strokes to form the outline of the shape until you have come close to representing the shape in proper proportion. Use very light lines to correct any mistakes. Do not be concerned with the exactness of each line, for your sketch should look spontaneous. If, when you are finished, you see a gross mistake, use the kneaded eraser to remove the lines.

When you are finished with the outline, use a 2B pencil to accomplish shading and to darken the outline of the shape. Keep the pencil sharpened at all times. When finished, select another shape and repeat the above described technique. Complete this for each of the shapes.

SHADING AND THE STUMP

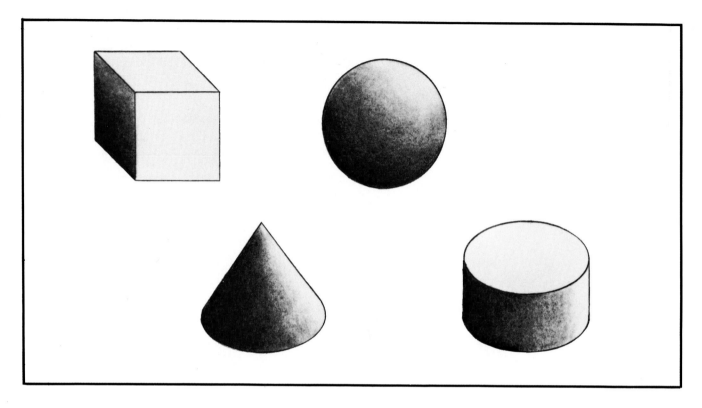

Illustration 45

Depth and roundness are obtained with shading. Select the shading style that you feel is most appropriate for your desired tone and texture.

You will now select one of the above figures to sketch and shade with one of the methods you have practiced. To begin, use a 2B pencil with a good chisel point. Select the methods that will offer a realistic tone and texture. Apply the shading lightly at first and add more until the shaded areas match those shown in the above illustration.

Stumps may be used to enhance a sketch by smoothing out shaded areas into a tonal plane. Many artists prefer to smooth out and blend tonal areas with their fingers. This method can be developed with practice. Since the finger is blunt, this method is effective only on large areas. The soft, coarse texture of the paper stump carries the color evenly over the sketch and can be controlled in smaller areas more easily than the fingertip. Color may be applied to the paper or to the stump. Stroking the medium on a sanding pad will produce a powder which the stump can be rubbed into. In either case, the color is then rubbed into the sketch paper with repeated strokes of the stump. Both stumps and tortillons may be used in these exercises. Tortillons may be used like the stump; however, the tortillon is constructed of harder paper and will maintain a sharper point for fine detail work. They are generally smaller in diameter than stumps.

Illustration 46

Stumps and tortillons may be used to enhance a sketch by smoothing shaded areas into a tonal plane.

Using the stump, start in the lightest tonal area and lightly rub the stump into this area until you have smoothed out the shading strokes left by the pencil. Be careful not to rub the shading outside of

SHADING AND THE STUMP

the outline. Shading must be done in the lighter areas first for the stump will pickup the graphite on its tip as the drawing is in development. The kneaded eraser can be used to lighten the tone or remove undesirable shaded areas.

Use the kneaded eraser to clean up the outline of the shape and any undesired smudges. Remember that a kneaded eraser absorbs color and you must, occasionally, knead it and reshape it to expose fresh areas.

When you have completed the first sketch, start with a cone-shaped outline and using a 2B pencil, begin shading. Care must be taken to taper the shading to a point at the top of the cone. Use the stump to smooth out the shading. Use the tortillon at the top of the cone.

You will notice that the original objects were flat but took on a third dimension when shaded. This is the basic technique in shading. Any area that is illuminated will take on similar tonal planes. Many objects will have textures that break the smooth tones, but the basic structure is still there. For instance, consider the bark of a tree. The texture of the bark will predominate, but the roundness of the trunk will still exist because of the graduation of the shading. The principles of shading you have just learned will apply to all your future sketching.

In this exercise, you will use a charcoal pencil to do the shading. Sharpen the pencil to a sharp chisel point and begin to shade a previously sketched outline of a circle. The shading will be performed a little differently since the shaded structure will take on a curved shape as it becomes darker near the bottom of the circle. To properly execute this technique, turn the paper upside down and use short curved strokes.

Gently lighten the stroke pressure as the shading strokes approach the center of the circle. Clean the stump by drawing it across the sanding pad.

Work the stump on the lightly shaded portion of the circle and gradually into the darker sections. You will notice the charcoal pencil shades much darker than does the graphite pencil. The final effect will be a much darker area and thus will indicate additional volume.

Try the same technique with the cylinder, working the shading strokes from the left to the right side of the cylinder. After cleaning the stump, use it to smooth out the shading.

When you are working the deep shaded areas, there is no need to repeatedly clean the stump. It is only the lighter areas that concern a clean stump. Some artists use a different stump for each area. Remember, the kneaded eraser can lift out unwanted pigment.

When you have completed the five examples, hold them away from you and study them. Do the ball, cone, and cylinder appear round? Does the cube appear to have depth? If your answer is no to any of these questions, try to figure out why, and repeat the sketches until you are satisfied with the final results.

This exercise has helped you to realize the depth and roundness of shapes, and also enabled you to draw them with representation. Now that you have learned to perceive shade tones, select objects in your surroundings and sketch them, examine the sketches, and proceed to shade them.

Illustration 47
Cleaning and sharpening of the stump is accomplished by drawing across the sanding pad.

PERSPECTIVE

LESSON 3

Almost every object sketched will be subject to perspective. Observe the different proportions between those surfaces closer to you as opposed to those farther away. When you change your position, those surfaces will also change in their size relationship to one another, or perspective.

Use a ruler and hold it up in front of you to compare the size of the surfaces you intend to sketch. Objects that are farther away will look smaller than those which are close. This is the basis for perspective. There are rules you can learn that will enable you to understand and apply perspective to your sketching, giving it depth and realism.

When you observe the subject you intend to draw, notice the point that is closest to you. This point describes two planes — horizontal and vertical. You must attempt to represent these two planes on paper. This is done by drawing a horizontal line and a vertical line.

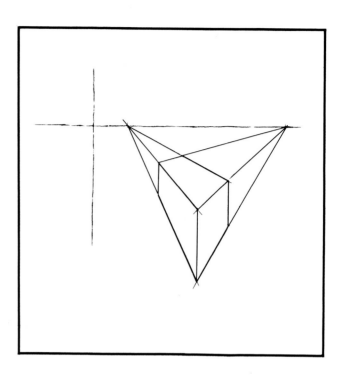

Illustration 49
Every object you sketch will have linear depth relative to these two planes.

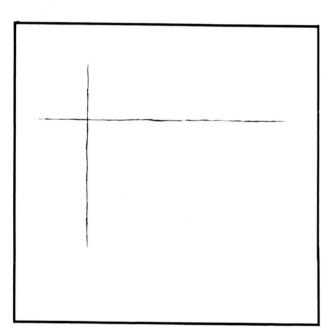

Illustration 48
When you study your subject, you must observe the two dimensions — horizontal and vertical.

Every object you sketch will have its linear depth drawn relative to these two planes.

All objects above and below the horizon line will be smaller in size as their planes extend toward the horizon. The horizon line is always in front of and level with the sight of the observer. Be sure that your eye level does not change after you have begun to sketch for this could result in distortion of your subject.

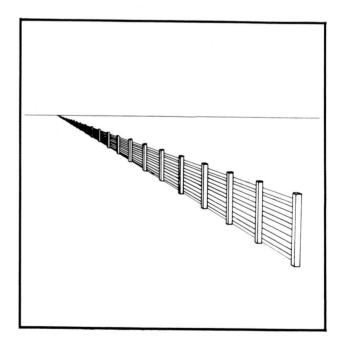

Illustration 50
The fence offers a good example of an object diminishing towards its vanishing point on the horizon line.

A different vanishing point will be needed for each object in your sketch, but each point will share a common horizon line. All planes of the same object will have the same vanishing point.

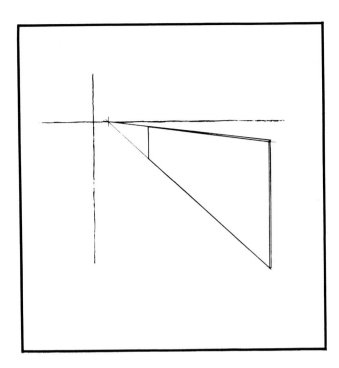

Illustration 51
A single object shares the same vanishing point.

When multiple objects have planes that are aligned vertically, the planes will have the same vanishing point. Objects that are not vertically aligned will have different vanishing points.

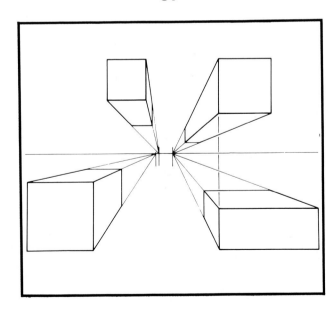

Illustration 52
When multiple objects have planes that are aligned vertically, they will have the same vanishing point. Objects having planes that are not vertically aligned will have different vanishing points. An example of multiple objects in vertical alignment and non-alignment with the same vanishing points respectively.

A cube, in which all sides are parallel and equal, will have all sides taper together as they extend towards the vanishing point. If diagonal lines were drawn between all four corners, those lines would intersect exactly in the middle of the cube side.

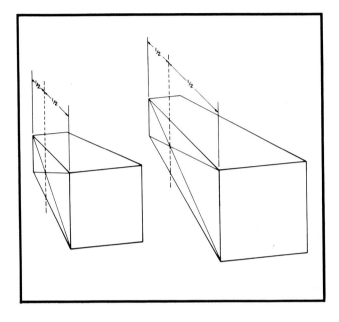

Illustration 53
This principle can be used to check to see if the figure is in proper perspective.

This practice will also work effectively with a rectangle.

It often becomes necessary to sketch a circle in perspective. When sketching a circle in perspective, the original plane of the circle will be tilted away from the observer's view point.

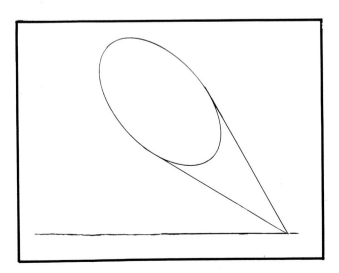

Illustration 54
An example of a circle sketched in perspective.

PERSPECTIVE

The plane can be tilted in any direction and at any angle, depending on the position of the observer. This is a common problem in sketching. Imagine looking at a wheel laying on the ground. If you stood directly over the wheel, the wheel would be perfectly round, but as you move away from the wheel it begins to take on an elliptical shape. Drawing this ellipse in proper perspective can be difficult.

Circular planes are determined in the same manner described previously. Instead of the sides tapering with linear extension, the circular plane becomes an ellipse that is directly proportional to the angle of the plane it lies on. Since we can determine the angle of that plane using the methods that apply to other planes, draw the circle in a square and then lay this figure on the plane you have determined.

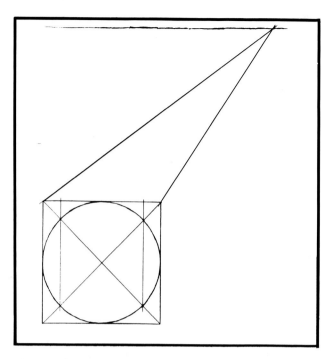

Illustration 56

Construct diagonals within the square. These diagonals will intersect the circle at 4 points. Draw vertical lines connecting the intersecting lines.

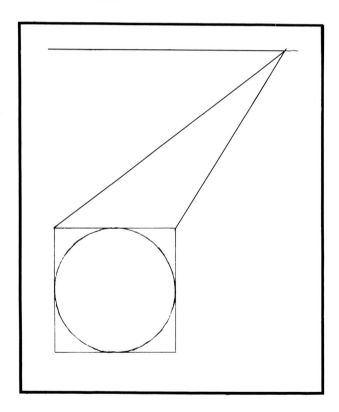

Illustration 55

First, draw a circle tangent to 4 points in a square.

By placing diagonals within the square, the diagonals will intersect the circle at four points.

Place this square in a position directly below the space that the circular plane will occupy in your sketch. At the intersections of the diagonals and the circle, draw vertical lines touching the sides of the square. If another vertical line were drawn through the center of the circle and extended to the horizon line, you will have determined the vanishing point for the circle.

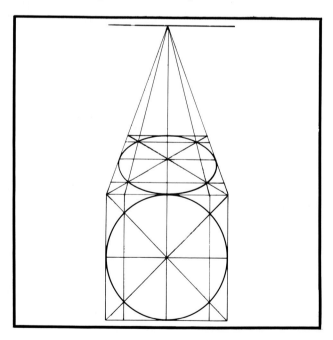

Illustration 57

At the points where the vertical lines intersect at the top of the square, draw lines to the vanishing corners of the original plane. Draw a horizontal line at the point where these diagonals touch the outside lines to the vanishing points. A plane similar to the first has been constructed in perspective. There are now 8 points that can used to construct a circle in perspective within the new plane.

Extend lines to the vanishing point from each of the top corners of the square. Then extend the other two lines that intersect the top line of the square to the vanishing point. At this point, for the ellipse construction, you will have to take a measurement of the object. Hold a ruler in front of your eye and make a visual measurement of the height of the ellipse.

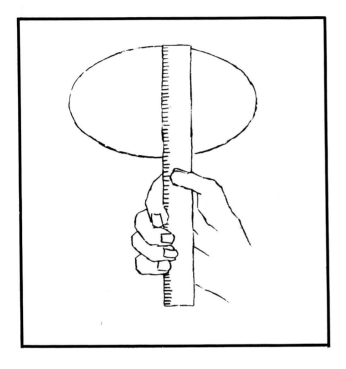

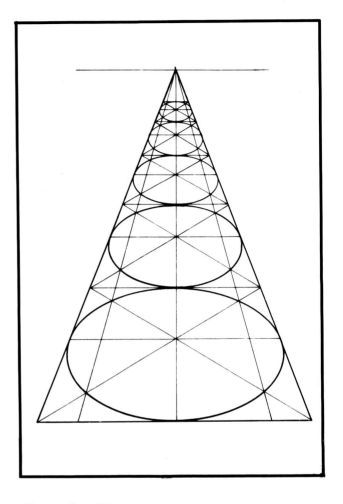

Illustration 58

To check the ellipse (the circle drawn in perspective), hold a ruler upright and sight a measurement of the circular plane in perspective. The proportions in your sketch should correspond to those measured.

Transfer this measurement to the center line leading to the vanishing point. This is the outer dimension of the ellipse. Draw a horizontal line at this point, recreating the square of an angled plane. Construct diagonals inside the angled square. The points at which these diagonals meet the lines on either side of the center line will correspond to the same intersection on the circle inside the square. You then sketch the ellipse using the eight points as a guide. This is an involved method, but it is the only accurate way of drawing an angled circle in perspective. After this method is mastered, most artists will be able to visualize the perspective and draw the ellipse freehand.

Additional circular conversions to ellipses can be made using the same method on the same plane extending to the same vanishing point.

For practice, lay out circles and develop their perspective.

Illustration 59

Additional ellipses can be drawn all the way to the vanishing point with the same projection.

DIRECT OBSERVATION

LESSON 4

Lay a milk carton on its side in a well-illuminated area. Position it such that one end extends toward a vanishing point. Position yourself so that you can observe two sides and the opening end.

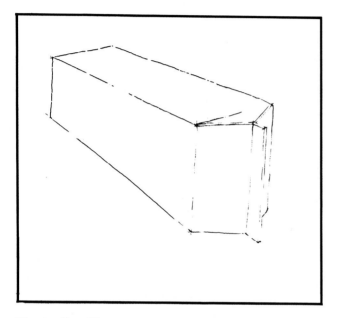

Illustration 60
A milk carton is a good object to draw when applying the principles of perspective.

Lay out the sketch paper using the methods of perspective previously defined. Once you have determined where the sketch is going to be drawn, begin to draw the outline lightly using an HB graphite pencil. Conform to all rules of perspective.

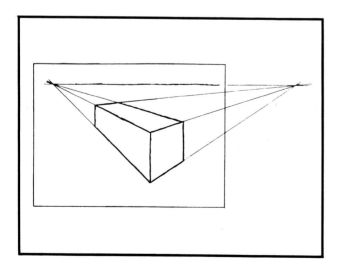

Illustration 61
The vanishing point and horizon line may fall off the surface of the paper.

When sketching an object that is close, the horizon may not fall within the area on the sketch paper. In this case you have to estimate where the horizon line and vanishing point would be placed. Keeping that imaginary point in mind it is somewhat easier to draw the converging sides of a rectangle diminishing towards that point.

At this point, constructive self-criticism is necessary. If your sketch looks distorted, determine what went wrong and make the necessary corrections until your sketch looks exactly like the carton in front of you.

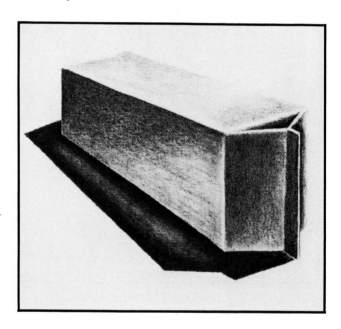

Illustration 62
Shading will enhance the reality of the object and provide depth and illumination.

When the outline is complete with the proper perspective achieved, darken the outline with a 2B charcoal pencil, sharpened to a chisel point. Use the sharp end of the chisel point to draw sharp, clear lines. If the pencil becomes dull, resharpen it on the sanding pad.

The edges on the carton sketch that appear to be illuminated should not be darkened; too much accent on these edges will make them appear too predominant and unrealistic.

After the outline is complete, observe the shading on the carton. Begin shading the sketch. This may be difficult in the area of the folds of the carton. If you make mistakes, use the kneaded eraser to help you correct them. Use the stump to smooth out the shading where necessary. Continue to work the areas with the stump and kneaded eraser until all planes look realistic. The tortillon will be needed in the sharp angled areas and corners.

DIRECT OBSERVATION

When you are satisfied with the final sketch, preserve your art with a fixative, following the directions carefully. This will assure permanency and allow the sketch to be handled without damage to the surface.

Select simple, common objects around the house and follow the same sketching procedures until you become adept in your technique of representation.

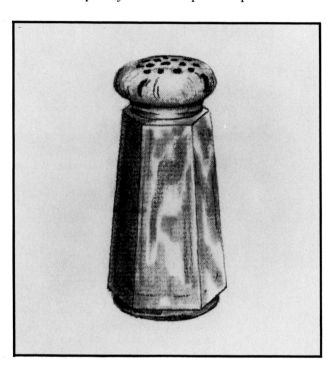

Illustration 63
A salt shaker would be a good object for a beginner to sketch. Two or more types of shading can be used.

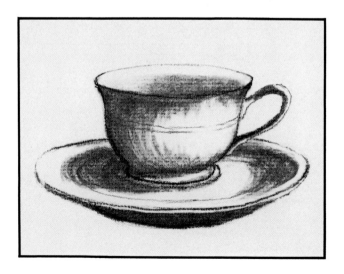

Illustration 64
Cup and saucer sketching allows practice of projection of circular forms into perspective ellipses. Volume must be developed with shading technique.

Thus far the exercises have included the use of the stump to smooth out shaded areas. Instead of doing this, you can apply the shading in such a way that smoothing out is not necessary. Refer back to Lesson 1 and determine which methods you prefer. With these types of applied shading, your art takes on more of an interpretative form and is not just copying. Remember that the texture of the paper you use is directly related to the final texture of the shading.

When sketching, you must always consider the relationship of the size of the objects you are sketching. It is important that each plane sketched has correct proportions and texture relative to the planes of the other objects. The principles governing proportion correlate to the rules of perspective. They both deal with diminished planes that recede to the vanishing point. When objects are separated by space, measure the objects by holding a ruler in front of your line of sight. This is the most accurate way to make a size comparison. There will be occasions where the measure and transfer method can be altered for accent or balance.

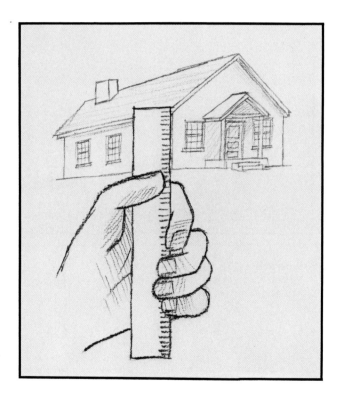

Illustration 65
Planes within a scene can be measured by placing a ruler in the line of sight, reading the ruler scale, and transferring these measurements to the sketch.

When the main objects in a sketch have been placed in the proper proportion, peripheral objects will be easy to draw and position. The larger objects act as a guide for placement of the smaller objects.

DIRECT OBSERVATION

Illustration 66
 When the primary object is properly placed and in the right proportion, peripheral objects will be easy to position and draw with correct size relationships.

CHARCOAL CRAYON

With the charcoal crayon, the artist can create a very broad sketching stroke that will reveal considerable texture. Charcoal crayons are available in many different shapes and sizes. There are hard ones, soft ones, round ones, and square ones. A soft crayon is recommended for the following exercises.

The charcoal crayon will smudge easily and care must be taken to avoid touching the sketch while drawing. To sharpen the crayon, use the sanding pad only. Many different points may be sanded on the crayon, but in the beginning use a plain, flat, chisel point.

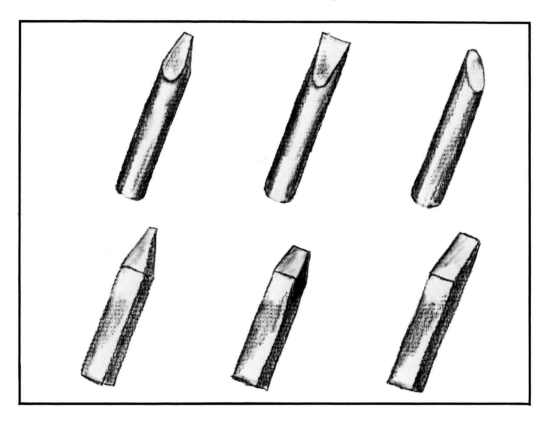

Illustration 67
 To sharpen the crayon, rub it on the sanding pad. Points are shaped to fit the nature of the sketching or shading effects desired.

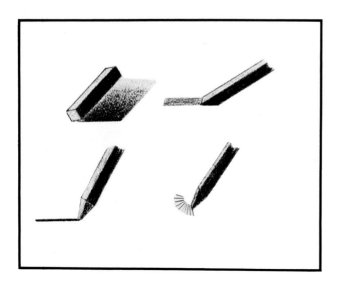

Illustration 68
 For strokes as wide as the crayon itself, sharpen the crayon to a chisel point and pull it across the areas to create a stroke that is even and consistent. Break the crayon to a size to match the width of the stroke desired. Hold the crayon and apply pressure over the area which is to be shaded. To draw fine lines, sharpen the crayon on all four sides to produce a fine chisel point. You can then use the sharp edge for fine lines and narrow shading strokes. When applying the shading stroke with a fine chisel point, hold the crayon at a low angle to provide increased contact with the paper.

A chisel point is obtained by rubbing the crayon on the sandpaper until a flat point is obtained at the end of the crayon.

Try different shading strokes with the crayon until you have a feel for its effects. Attempt a variety of strokes, broad and narrow, using tapered pressure. Also, try to develop curves with the strokes.

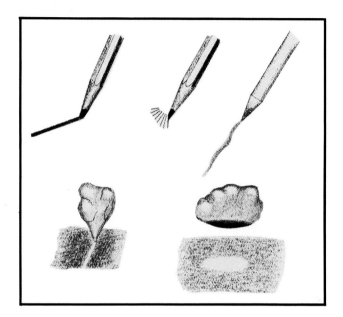

Illustration 69

A chisel point on the pencil may also be used to apply a shading stroke. Less sharpening is needed but the width of the shading stroke is limited to the width of the point. The sharp edge of a chisel point on a pencil may be used for fine lines. When fine lines are alternated with shading strokes, the wear from shading will sharpen the point.

Form the kneaded eraser into a sharp point to lift color in lines or detailed areas. Reshape the eraser as it becomes saturated with pigment or broad in shape. Large areas of color may be lifted when the kneaded eraser is applied on a flat side. Remember to reshape the eraser frequently so pigment is not deposited back onto the paper.

The stump can be used to develop soft, wavy lines necessary in good composition. Pigment must be applied frequently to the stump.

It is now time to try your first landscape. You should be able to find all the elements for good composition right in your own neighborhood or at a local park.

To sketch successfully, the artist must first see his subject as a pattern. He must look for lines and masses and must learn to see them as part of the overall design. A suggestion to the beginner is to study the subject frequently through a rectangular frame of blackened cardboard.

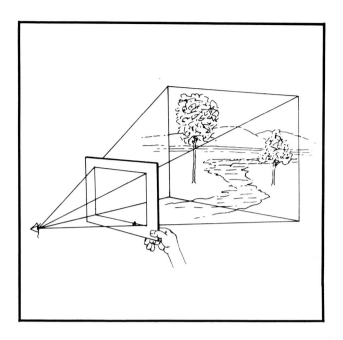

Illustration 70
Cut a frame from cardboard to view the scene and study the elements. Changing positions may help to obtain a view which would have better composition.

To vary the amount of subject visualized through the frame, change the distance between the cardboard and your eye.

Carefully select the subject matter you are planning to sketch. If you have a scene that seems tempting, look at it from a number of different positions to get various angles of view. For example, a tree is useful to the artist only when the direction of its lines are good and the overall shape is in a satisfactory position. Use the cardboard frame to create the boundaries of your drawing.

Once you have chosen a scene, gather paper, charcoal crayons, a kneaded eraser, a sanding pad, a ruler, and begin your sketch. Imagine how the scene will look on the paper and where each object will be positioned. Use the ruler to obtain proper proportions.

The subjects that are nearest to you will appear to *lay on top* of the background. For this reason, finish the scenery in the background first. In other words, sketch towards the foreground. Use the texture in the paper to reflect the texture in the scene. When sketching trees, use strokes to draw the massing foliage. Remember that the trees in the background will have lighter foliage than those in the foreground. Remember, also, that there are generally reflections in the water. If the water is still, the reflections will duplicate the scene reflected and must be aligned vertically to look natural. Clouds may look predominant, but be careful not to detract from the overall composition of the scene by placing too much emphasis on the clouds.

CHARCOAL CRAYON

Learn to use the crayon in a variety of ways. Be aware of the value of pressure in the shading stroke. Do not be afraid to put texture in the scene. Remember, you are *sketching* not photographing. Shading strokes will contribute texture. Proportion will give scale and depth to the scene. Do not become a slave to intricate detail. Experiment and see how quickly the basic techniques and skills develop.

Select several scenes to sketch and notice how your art improves with each succeeding sketch. Sketch without a stump and rely on the use of your crayon and textured sketching paper to provide a texture which suppresses detail yet depicts a measure of reality without dedication to the minute.

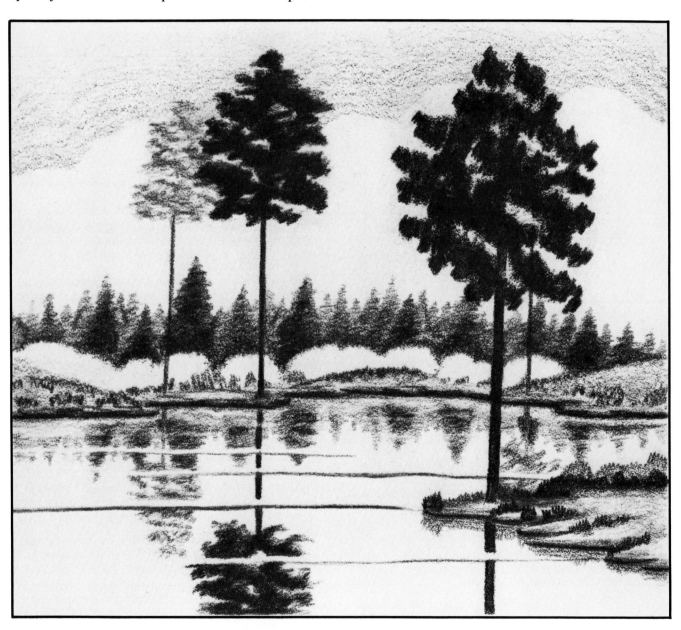

Illustration 71
 Perform sketches without using a stump. Learn to use the crayon in a variety of ways. Do not be afraid to experiment with texture; you are sketching not photographing.

You can save a great deal of time if you sketch with two crayons: one with a sharp point for intricate detail and one with a broad, flat chisel point for shading strokes.

When your sketches are finished, spray them with fixative. Now you have the beginnings of an art collection.

SANGUINE CRAYON

LESSON 6

The word *sanguine* means blood color and hence a sanguine medium, which is red in color. Sanguine is an earth color and contains red iron oxide which is mixed with kaolin clays to obtain a pigment extremely rich in color.

Sanguine is used in a way similar to the charcoal crayon, however, the finished sketches have a warmth which renders a unique intimacy. Sanguine is available in pencil or crayon, hard or soft form, and in round or square shape. Colored sketch papers can be used to enhance the effects of sanguine. Paper colors frequently used include ivory, cream, pink, and brown.

Sanguine should be used to sketch when a romantic mood is trying to be expressed.

In the next exercise, you will see how the shading stroke is used as a base for the entire sketch. If you can learn stroking techniques with the sanguine crayon, you can master a sketching technique that has infinite application. In much the same way you learned to do shading lines, you now need to practice the same lines adding a slight curve to the shading stroke. Apply a little more pressure and separate the strokes from one another.

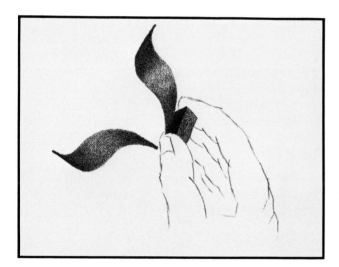

Illustration 72

*As with the charcoal crayon, apply pressure at the beginning of the stroke and relieve pressure during the stroke. This is called **feathering** the stroke, bringing out the full texture of the paper and providing spontaneous, artistic shading.*

Break about a half inch off the end of the sanguine crayon. Hold the small piece of the crayon flat with one of the four corners touching the sketch. Hold the crayon at about a 30 degree angle to the paper and apply pressure so that it is exerted on the point touching the paper. Pull the crayon

slightly to the right and then straight down without changing the angle or allowing the crayon to fall to one side. After drawing about one inch of a stroke, pull the crayon to the right at the same angle that you started the stroke. You will have to practice this stroke several times to master it.

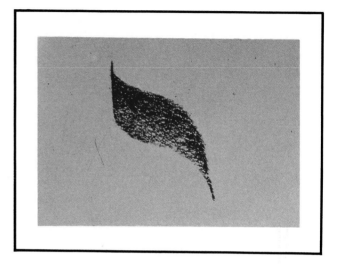

Illustration 73

Hold the crayon at about a 30 degree angle and apply considerable pressure so the edge of the crayon touches the sketch paper. Pull the crayon slightly to the right and then straight down. While pulling down, decrease the applied pressure on the crayon.

When you have mastered this stroke, turn the sketch paper upside down and repeat the stroke directly above the previously sketched stroke.

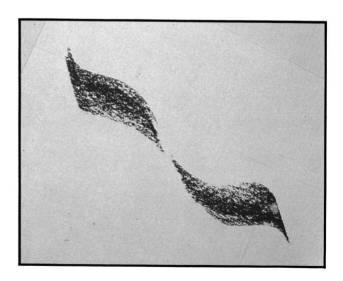

Illustration 74

This is a combination of two strokes in a duplication of the first stroke, but the paper is turned upside down and the stroke is repeated so the tail of the second stroke comes very near to the tail of the first stroke.

When the double stroke is complete and looks similar to the illustration, rotate the sketch paper about 90 degrees and place another shading stroke vertically so that the finished tail of the stroke ends about a half an inch above the center of the other two strokes. Rotate the paper about 180 degrees and repeat the stroke so that it is placed near where the other strokes ended. You now have four strokes arranged in a circle.

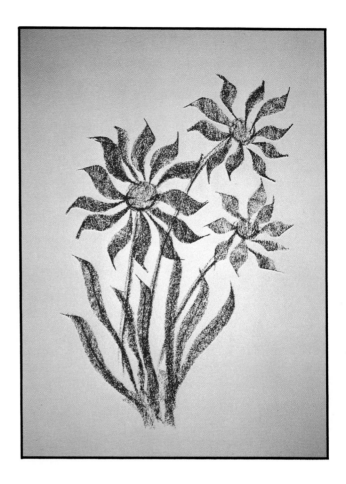

Illustration 76

Leaves at the base of the bouquet are simply extended shading strokes. Add stems for each blossom.

When the blossoms are complete, add a center by lightly applying the end of the crayon in a small circle at the juncture of all the petals. Underscore this center with a circular line using the sharp edge of the crayon, indicating the stamen. Then use the same stroke under the blossom to indicate leaves, however, this time when you pull down, pull 5 to 8 inches before you make the pull to the right. Add several leaves to make the bouquet complete.

Next you will draw stems. Start under each blossom and make a sharp, vertical line with a slight curve descending to the base of the leaves. About one eighth of an inch from the first sharp line drawn, make another and try to keep this line parallel to the first line. Repeat these lines for stems under each blossom.

Your sanguine sketch of a bouquet is now complete. Do not do anything more to it including using the stump. You have taken full advantage of the paper texture and you should be able to see how the texture of the paper adds assemblance of reality to the scene, yet you did not dedicate effort to developing the minute. Do, however, spray the sketch with fixative.

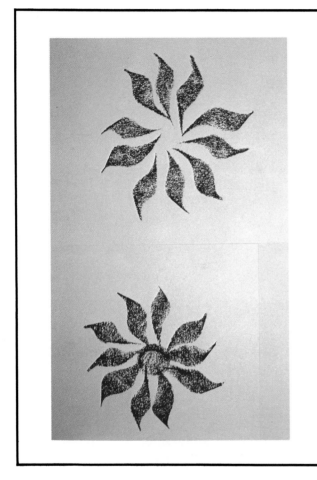

Illustration 75

Rotate the paper about 90 degrees and repeat the shading stroke. Rotate the paper 180 degrees and repeat. Continue this process until the area is full of shading strokes. Shade the center and a blossom is created.

Next you will place two shading strokes in the space between those already drawn to start filling the empty spaces between strokes. Continue this procedure until you have filled the spaces.

You have created a blossom! Now attempt to visualize three blossoms on one piece of paper to make a bouquet. Blossoms in a bouquet would be of different sizes adding interest to the floral arrangement. Try making blossoms of varied sizes, planning ahead of time where you are going to place them.

SANGUINE CRAYON

As you progress in sketching, you will find that you will be able to develop your own shading strokes. You will be able to use varying lengths of crayons and varying movements within the stroke to duplicate patterns in your subject without resorting to detailing. This is the essence of individualism that will lead you to the development of your own style. Continue to do sketches like this one of the subjects in your environment. You will be surprised at the skills that you have developed!

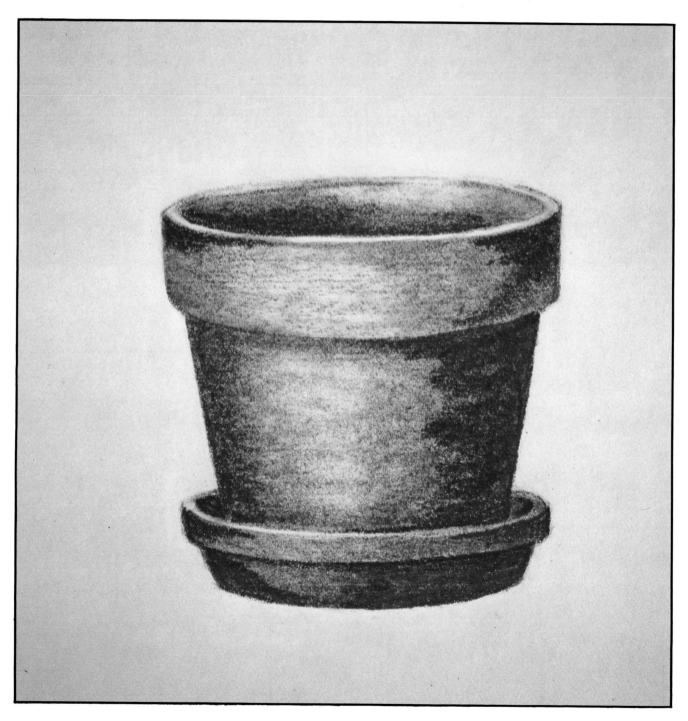

Illustration 77
A flower pot would be a good subject for experimenting with sanguine.

PRESERVING YOUR WORK

LESSON 7

After you have finished a sketch, it is natural that you would want to preserve it. After working with charcoal, you may have noticed that the surface of the sketch is delicate. A preservative is needed to toughen the surface and make the sketch less prone to damage. For charcoal or pastel, the preservative is called a fixative. Before aerosol became popular, artists made their own fixative by dissolving rock resin in wood alcohol. Now synthetic resins are available.

To avoid abrasion, the fixative is sprayed lightly on the surface of a charcoal sketch or pastel painting. A quality fixative will not alter the image, color, or texture of the surface. Directions for use are generally on the label and should be followed closely. If a heavy layer of fixative is applied leaching can occur, especially if the base color is darker than the top color.

With high quality fixatives, it is possible to rework the art if necessary. It has also been observed that a fixative can be used to coat an area that has been overworked to the point that the texture of the paper starts to break up. After the fixative dries, you will find that additional pigment can be worked in without additional damage to the paper texture. Of course, this depends on the extent of the original damage to the paper.

Illustration 78
To help prevent damage, a fixative is sprayed lightly on the surface of the drawing as a preservative.

After completing the sketch, it should be mounted to keep it flat. Two methods of mounting are available: spray mounting and dry mounting. For dry mounting, an expensive mounting press is required. Some art stores or frame shops are equipped to do this. Spray mounting is less expensive and is easily learned. An aerosol spray adhesive can be found in most art supply stores. Specific instructions are included on the label and should be followed very closely. In most instances, both the back of the sketch and the front side of the mounting board are coated with adhesive. Care must be taken to perfectly align the sketch on the mount board because most cannot be repositioned once contact is made. Generally, a smooth, white-surfaced mount board is recommended for mounting sketches. Double ply mounting board is available when a stiffer and thicker mount base is needed.

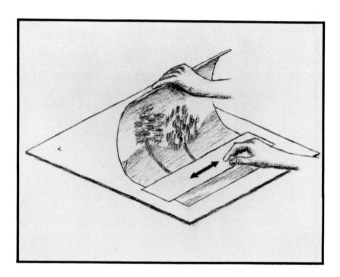

Illustration 79
During adhesive mounting, both the back of the sketch paper and the mounting board are sprayed with adhesive.

Framing offers even greater protection from damage to sketches. Picture frames are available in all sizes and prices and in a wide variety of styles. Some sketches will require matting before framing. This should be seriously considered by the artist before framing the art. By choosing to mat a sketch, the size of the required frame usually increases. When framing sketches with a mat, never use glare-free glass. The surface of this glass has a texture, and when it is separated from the sketch by a mat the texture of the glass causes the image to blur slightly.

Mat boards are available from most art supply stores in a wide variety of colors and textures that would complement almost any piece of art. The standard board size is 32" by 40", but boards are sometimes available in half sheets. Other than

aesthetics, mat boards will keep the glass away from the surface of the sketch. Over a period of time, if a sketch is framed under glass without a mat, some of the pigment will lift off the sketch and onto the glass.

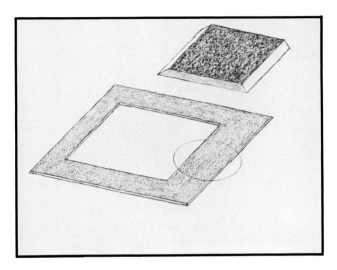

Illustration 80
A bevel cut, revealing the thickness of the mat board, is generally preferred when matting a sketch.

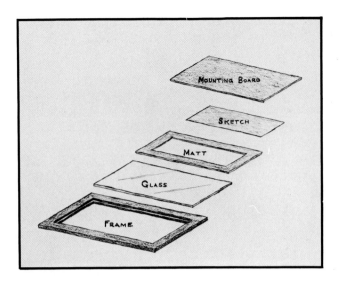

Illustration 81
Matting complements any sketch if done with proper consideration. The order of assembly is shown for framing a sketch — mounting board, sketch, mat, glass, and frame.

Mat-cutting equipment can be purchased, but it is relatively inexpensive to have a mat cut at an art store. In some stores, you can buy a mat, have it cut, and also purchase a frame. Matting complements any sketch and should be a serious consideration by the artist.

NOTE FROM THE AUTHOR

COLUMBIA SPACE SHUTTLE

Successful sketches have a rhythm that helps to tell their story. This rhythm can be learned through practice and close observation of other paintings and sketches. Once rhythm has been incorporated into a rough sketch, the details and shading will provide the approach to realism. This will help the observer to understand the thoughts and feelings of the artist's interpretation.

Try not to copy the work of other artists. You now have all the facilities necessary for original sketches. As you continue in your art training, you will realize that the rules and principles you have learned through these exercises can be applied to other art forms — painting, watercolors, and pastels.

I hope that a new area of expression has been opened for the beginner through the experiences gained using this text. The need to communicate a visual idea can be very important and once results are achieved that are acceptable to the artist, the fulfillment of the creative urge can result in sketching sessions that are truly enjoyable.

It would make sense to exhibit one's work outside his inner circle of family and friends. One way to do this would be to join a local art club or group which would qualify you to enter your work in exhibitions. Also, local libraries, restaurants and theatres are sometimes receptive to exhibiting local work. Success in exhibiting is exciting, but not the end in itself. To be the medium through which a good sketch or pastel painting comes to life is the most stimulating experience for an artist.

Retain the abilities you have learned, add to them, and continue to turn out good sketches.

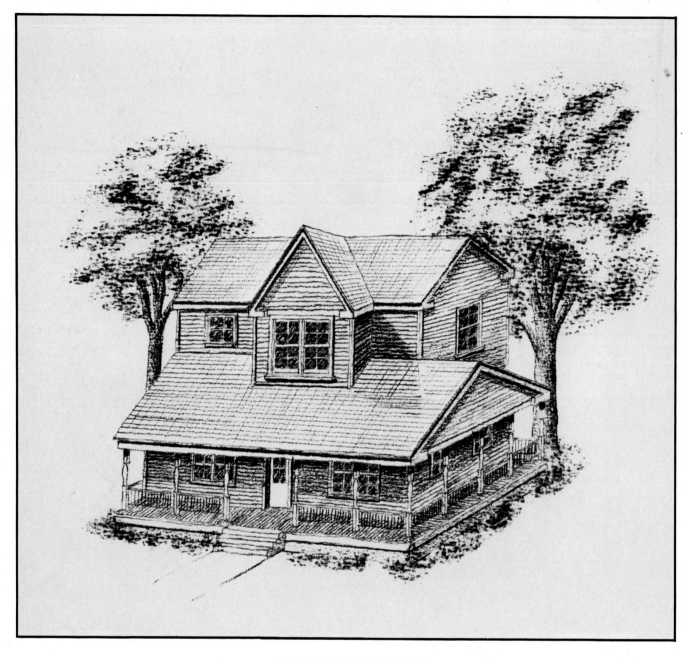

COUNTRY FARM HOUSE